SOUTH AFRICA
GERALD HOBERMAN

PHOTOGRAPHS IN CELEBRATION OF
THE SPLENDOUR AND DIVERSITY OF
THIS JEWEL OF THE AFRICAN CONTINENT

TEXT BY DON PINNOCK

GERALD HOBERMAN PUBLICATIONS
CAPE TOWN

Concept, design, photography and production control
Gerald Hoberman

ISBN 1–919734–11-2
Copyright subsists in this material
Duplication by any means is prohibited without written permission from the coyright holder.
Copyright © Gerald Hoberman 1998

First published 1998

Published by:
Gerald Hoberman Publications
PO Box 60044, Victoria Junction, 8005, Cape Town, South Africa
Phone: 27(021) 419–6657 Fax: 27(021) 418–5987 Cellular: 082 560–2120
E-mail: hobercol@global.co.za

Printed with pride in Cape Town

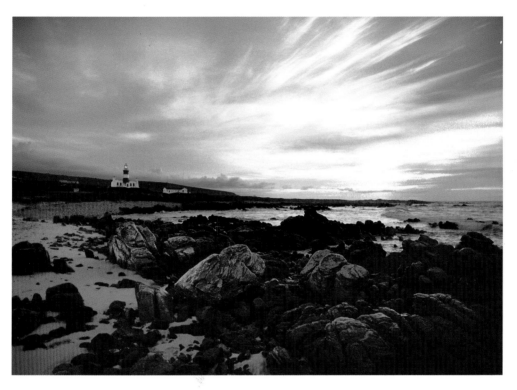

CAPE AGULHAS, SOUTHERNMOST TIP OF AFRICA

Cape Agulhas lies at the southernmost tip of Africa. Beyond the lighthouse is the shallow Agulhas Bank, one of the richest fishing grounds in the southern hemisphere. It stretches for a distance of 250 kilometres before dropping into the abyssal depths of the southern seas. On his homeward journey in 1488 Portuguese explorer Bartolomeu Dias named the cape St Brendan, but it was later changed to Agulhas, probably because compass needles (*agulhas*) of early navigators showed no magnetic deviation from true north here. The first lighthouse was built there in 1848 and warned mariners of the treacherous coast for more than a hundred years, before it was replaced by a high-powered light in 1962.

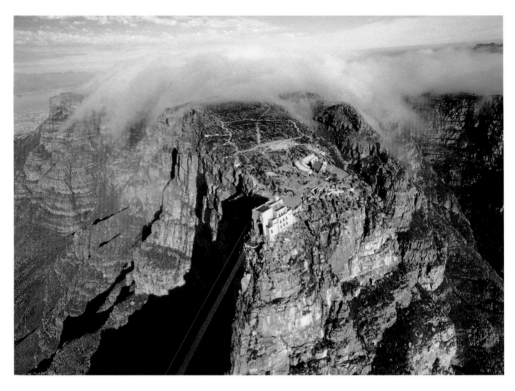

TABLE MOUNTAIN, CAPE PENINSULA NATIONAL PARK

World-famous Table Mountain is a central feature of the Cape Peninsula National Park. The park, which also includes Cape Point, is a renowned floral sanctuary, containing many of the 6,000 plant species making up the tiny Cape floral kingdom. About 1,470 species of *fynbos* (fine bush) grow on Table Mountain and about 1,080 species occur in the park's Good Hope section at Cape Point. Plants growing within the park are protected from the threats posed by alien vegetation, agriculture and urban growth. Visitors wanting to go up Table Mountain can take day walks to the top, or catch a four-minute ride in the cable car.

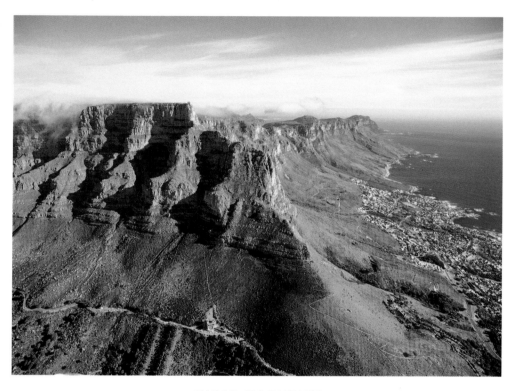

TABLE MOUNTAIN

If ever a land mass was designed to be the punctuation mark at the end of a continent, the Cape Peninsula must be it. Starting at the broad, flat-topped exclamation of Table Mountain on the Atlantic seaboard, it tapers off along the Twelve Apostles, narrows to a gnarled, sheer-sided finger rising out of the sea and ends up with a lone rock full stop. These rocky bastions are the remnants of sedimentary seabed, folded up out of the Mesozoic waters by the collision of tectonic plates. At some point in time the Table Mountain group became separated from the Cape Folded Mountains to the north, and during inter-glacial periods it was an island.

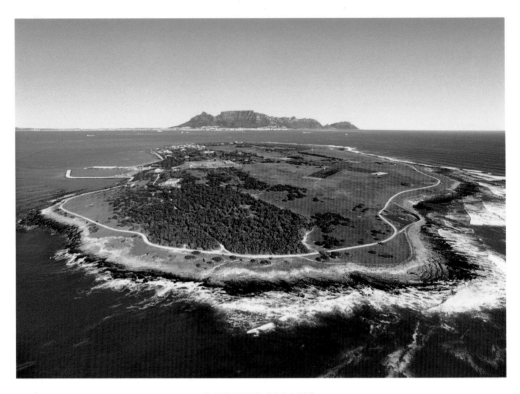

ROBBEN ISLAND

Even before Dutch governor Jan van Riebeeck placed his colonial stamp on the southern tip of Africa, Robben Island had housed its first prisoners. In 1615 the English landed ten convicts below Table Mountain. Their activities soon provoked an attack from the Khoikhoin and with a longboat begged from a passing ship they fled to the nearby island. Some died attempting to paddle out to passing ships, but the rest succeeded in hitching a ride to anyplace else. Robben Island later became a leper colony and, during the Second World War, an artillery garrison. In 1960 it became a prison for those who opposed apartheid, including Nelson Mandela. Today Robben Island is a museum and nature reserve.

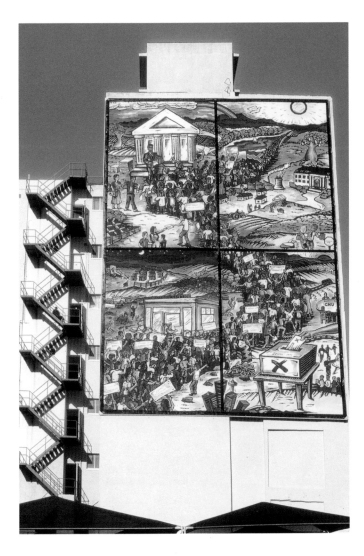

MURAL

The brief for the giant mural opposite the parliamentary buildings in Cape Town was daunting: to portray the struggle for freedom, democracy and the building of a nation. It was commissioned to commemorate the creation of South Africa's first democratic constitution. A small design company took up the challenge and its artists created four panels, giving the impression of looking through a window at different phases of the struggle for nationhood. The panel themes show the fight against apartheid, the democratic elections, the constitution-making process, and the acceptance of the new Constitution. Today any politician looking out from the parliament building is reminded of the nation's struggle for freedom and the aspirations of its ordinary citizens.

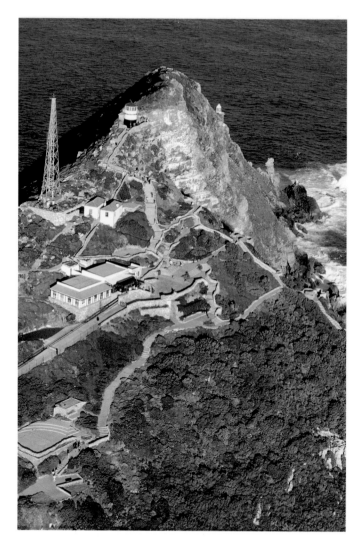

CAPE POINT PEAK, CAPE PENINSULA NATIONAL PARK

There are many who argue that it is at Cape Point that the cold Atlantic meets the warm Indian Ocean. But scientists – ever more pragmatic than romantic – insist that the meeting takes place further east, at Cape Agulhas. Thousands of people visit Cape Point, the southernmost tip of the Cape Peninsula, where they stand awe-struck by the raw beauty of this wave-lashed outcrop. It's an extremely visitor-friendly place, with a funicular railway to whisk you from the parking lot to the top, a network of paths to lookout posts offering spectacular vistas, and a restaurant with unequalled views. For those who like to walk, there's a 34-kilometre trail with an overnight hut.

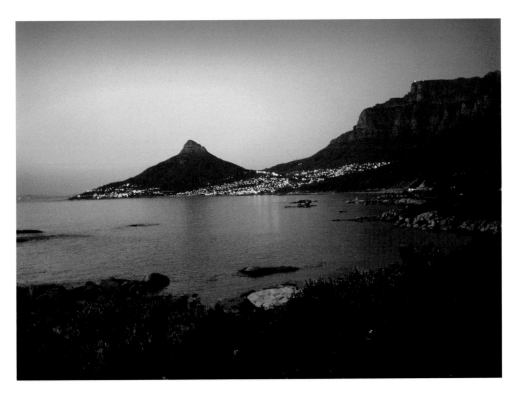

ATLANTIC SEABOARD AT SUNSET

Sir Frederick de Waal had a vision: to ring the Cape Peninsula with roads so daring, offering views so beautiful, that travellers would never forget their trip along them. Elected as Cape Administrator in 1910, he used his considerable political skill to get official sanction for his dream. Roads began to creep along the Peninsula's mountains: from the city to Wynberg; from Simon's Town to Cape Point; and from Sea Point along the feet of the Twelve Apostles to Hout Bay. When he had the towering cliff faces between Hout Bay and Noordhoek surveyed, many considered him quite mad, but De Waal had realised his dream when in 1922 Chapman's Peak drive was opened.

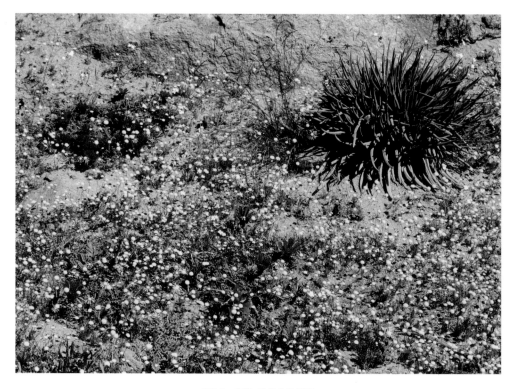

SEA OF COLOUR

If you travel north from Cape Town towards Springbok during the right season you will be overwhelmed by beauty hard to imagine in a land so harsh. As far as you can see, across vast stretches of sandveld and spreading over koppies, will be millions of flowers. In Namaqualand, where this explosion of colour takes place each spring, nearly 2,000 species of flower have been identified. In some areas the soil has been found to yield a staggering 10,600 flower bulbs in a square metre a spade deep. This is thought to be the highest such count in the world.

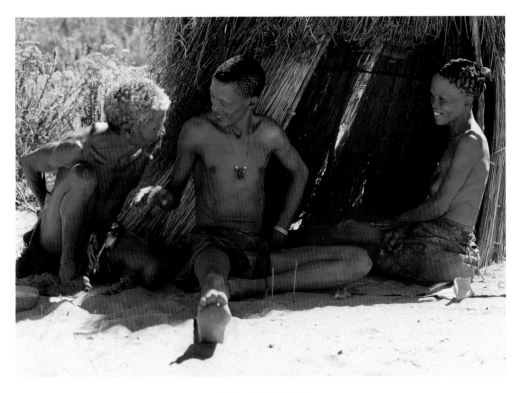

SAN CULTURE

The San have one of the most ancient cultures on earth. The earliest southern African rock art to have been dated – in Namibia's Apollo 11 cave – is nearly 27,000 years old. Given that the most recent paintings were done in the 1870s, that probably makes for an unbroken art tradition unequalled in the world. The consistency of images, styles and symbolism suggests that paintings functioned as a uniform communication system throughout the subcontinent.

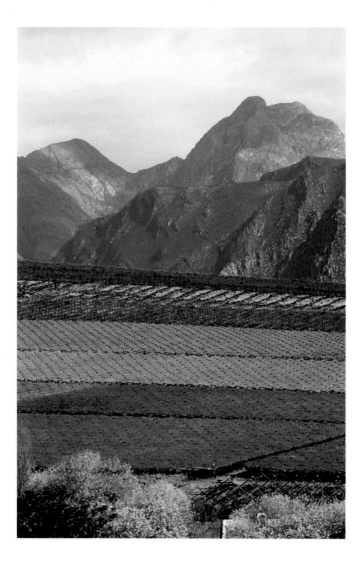

THE WINE ROUTE, HEX RIVER VALLEY

Grapes are a very particular fruit. They like plenty of moisture but not on their leaves and bunches. They prefer winter rain and summer sunshine and they grow best in well-drained, decomposed sandstone and shales. They respond well to cool water from passing streams. In the Hex River Valley they find all these ingredients, which is why some of the finest wines in South Africa come from there. The fertile valley, once the scrub-covered home of lions, giraffe, rhinoceros and antelope, is now intensively cultivated and immensely productive. In late autumn the valley offers an awesome spectacle when the leaves of Algerian barlinka vines turn an incredible shade of scarlet.

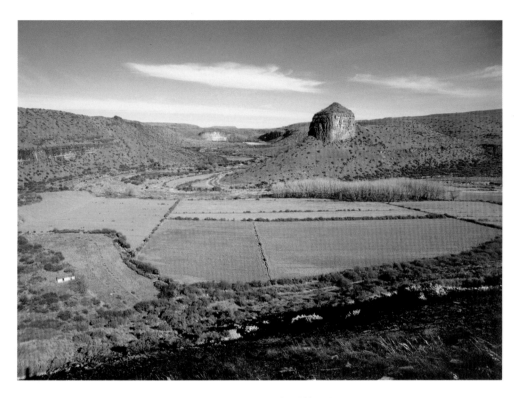

THE KAROO SYSTEM

The Karoo System, which covers about two-thirds of South Africa, is a deposit of deep sediments and it's still something of a mystery where all the material came from. The beds were laid down between 250 and 150 million years ago when swamps, lakes and immense forests covered the area. Beneath the quiet valleys of the Karoo are three distinct layers. Near the bottom lies the Ecca Series, rich in plant fossils and coal. Above it lies the Beaufort Series, full of dinosaur and amphibian fossils, and the uppermost layer is the Stormberg Series, consisting of wind-deposited sandstone and water-deposited shales rich in plant, reptile, fish and amphibian fossils.

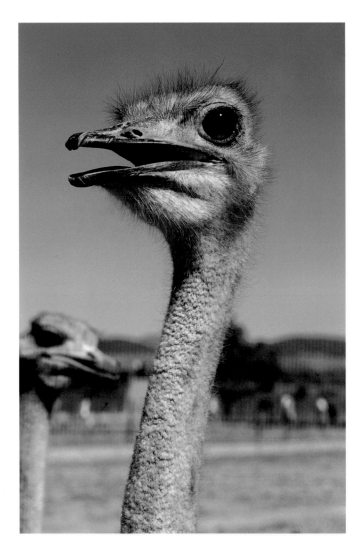

OSTRICHES, OUDTSHOORN

From the turn of the century to the First World War no woman of style in Europe or the United States would dare to appear in public without a feather cape or boa made from ostrich feathers. It's hard to say why the bubble burst, but by the end of the war farmers in the southern Cape town of Oudtshoorn were being forced out of the business in droves. Many families hung on, though, and today – although the ostrich population has been reduced from just under a million to some 170,000 – the town is still the ostrich capital of the world. And the giant birds, seeming to have more in common with dinosaurs, are as enigmatic as ever.

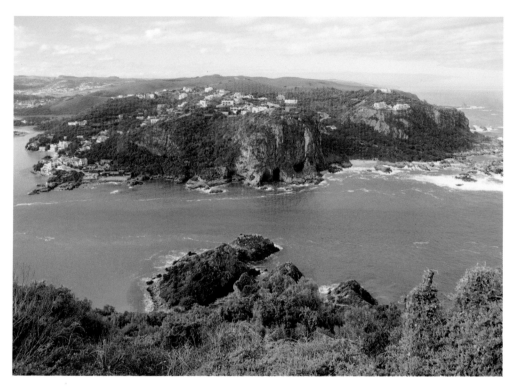

KNYSNA HEADS AND LAGOON, GARDEN ROUTE

Behind the famous Knysna Heads lies the Knysna Lagoon, a rich field of study for marine biologists. Its bottom varies from a deep, sea-facing mouth, through shallow channels to mud banks further inland. More than 200 species of fish live in its waters, including a rare seahorse unique to the lagoon. There's also an oyster hatchery where these delicacies can be bought or sampled over a glass of good wine. The pristine western side of the Heads is part of the Featherbed Nature Reserve and can be reached by boarding the cruise *John Benn*, which drops its passengers at the Featherbed Restaurant from where a vehicle will whisk them to the top.

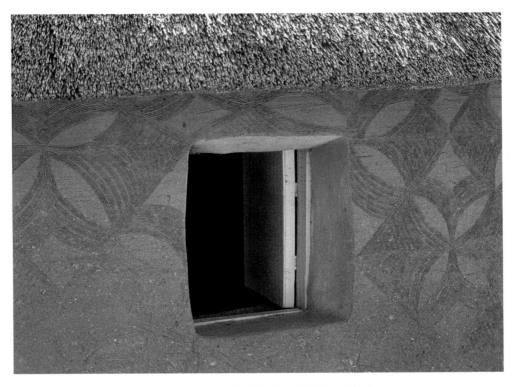

BASOTHO HUT WALL, FREE STATE

Like the Ndebele in the north, the Basotho have used the walls of their homes as their canvas, and elaborate patterning can be seen throughout many parts of South Africa. In the southeastern Free State and the mountain kingdom of Lesotho, wall painting is generally done with fingers on a wet, dung-plastered wall – though this was done with a table fork. These designs are believed to protect households from malevolent spirits.

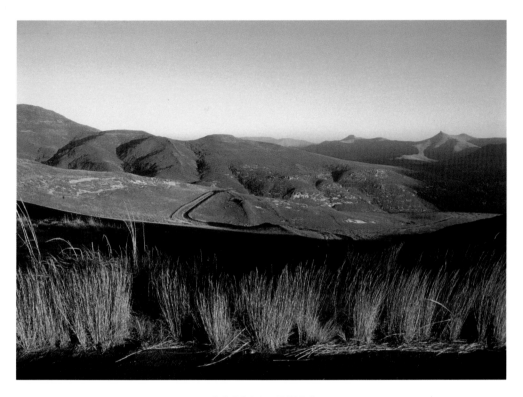

GOLDEN HILLS

Beyond the towering cliffs of the Golden Gate Highlands National Park are rolling highland hills which seem to go on forever. In the crisp mountain air black eagles and jackal buzzards soar and shy antelope regard human intruders for a moment then dash off to safer ground. Arum lilies, watsonias, fire lilies and red-hot pokers flourish in this corner of the Free State, but it is primarily grassland. Depending on the season, the mountains will be cloaked in yellow, brown or intense green and when a breeze blows the only sound will be the rustle of grass.

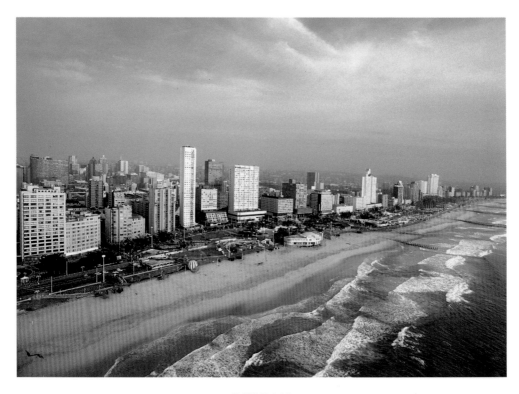

DURBAN

Some 100 million years ago Durban, and the surrounding countryside, was seabed. As the Indian Ocean receded, the bay and its distinctive promontories, the Point and the Bluff, emerged. Among the first people to settle in the area were the Lala, who hunted in the coastal forests and fished the shallows. The area got its first recorded name, *Terra do Natal* (land of the nativity), from the Portuguese explorer Vasco da Gama, who sailed up the coast on Christmas Day in 1497. Today Durban is the third largest city in South Africa and the country's sea and surf capital. Here, exotic Indian and Zulu markets rub shoulders with high-rise buildings in a laid-back, subtropical atmosphere.

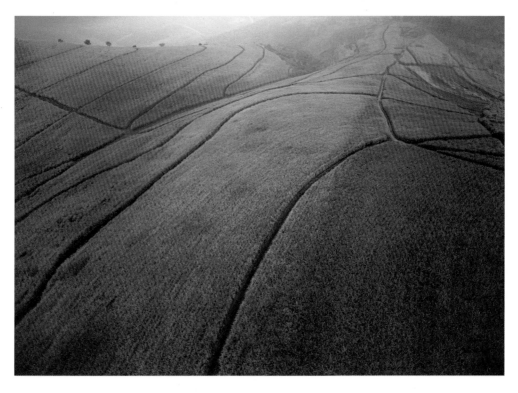

VALLEY OF A THOUSAND HILLS

Planting and harvesting sugar cane is labour-intensive work and, when the crop was first introduced into Natal in 1851, farmers hoped local people could be employed to do the work. But this type of cultivation held little attraction for them and planters looked to another source of labour – India. The first Indians arrived in 1860 and were set to work on limited contracts. Conditions on the farms were harsh and those who could found other occupations. Today the Indian community plays a vital role in the KwaZulu-Natal economy. The province's thriving sugar cane industry has ensured that South Africa ranks among the world's top sugar-producing countries.

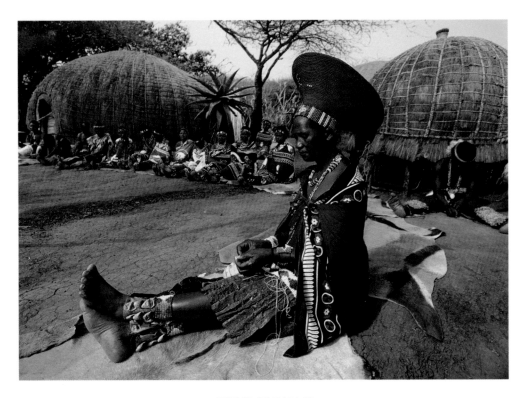

ZULU WOMAN

Within the traditional Zulu homestead there is a division of labour based on gender: the men work with livestock and women are involved with the production of cereals and child raising. The manufacture of fine beadwork and woven headgear, however, is generally a woman's task. Until blankets were introduced by European traders in the nineteenth century the main form of dress for both men and women was a cloak of well-tanned hide worn with the hair inside. Beneath this, men would generally wear only penis-sheaths attached to a loincloth. Women's cloaks were more generous in size, and could cover a child supported in a sling on the back.

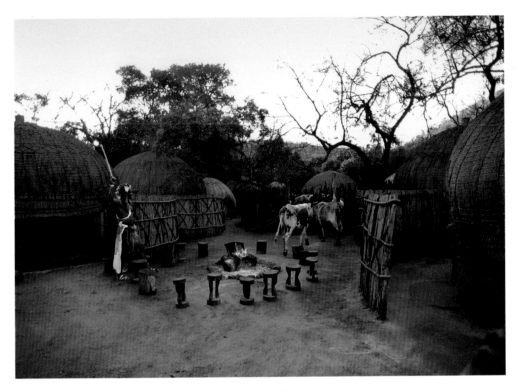

ZULU HOMESTEAD

The cattle kraal is the physical, social and spiritual centre of a rural Zulu homestead and in these areas cattle still represent both wealth and a link with the ancestors. If a man wishes to marry, cattle and gifts are exchanged between the families. This practice of *lobola* (bride-wealth) represents a transfer of wealth to the potential wife's father. So, while sons serve to extend clan strength, daughters stand to increase its wealth. This system favours first-born sons in that they inherit the bulk of their father's wealth, most of it in cattle, and so, if they are wealthy, they are able to have many wives, extend their lineage and, consequently, their family workforce.

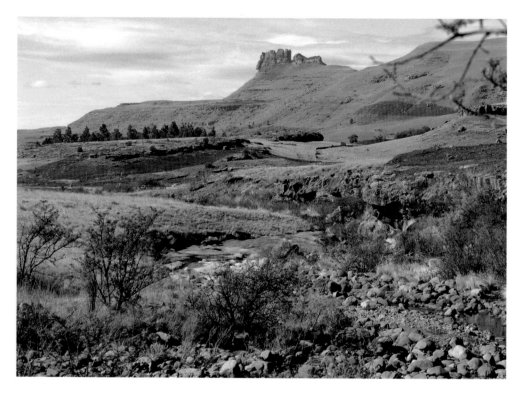

DRAKENSBERG

The Drakensberg is the child of water, wind and fire. For perhaps 100 million years South Africa was covered in swamps and forests. Then, around 180 million years ago, drought set in, demolishing the forests and reducing the land surface to mud, then shales and sand. Great rills of wind-lashed sand piled up, and when wind abandoned this plaything, fire took over, forcing basaltic lava through fissures in the earth's mantle, covering much of the surface to heights of about four kilometres above sea level. Then rains poured down, gouging deep valleys into the basalt and sculpting the landscape into the pinnacles, cliffs, rock overhangs and secret caves of the country's towering mountains.

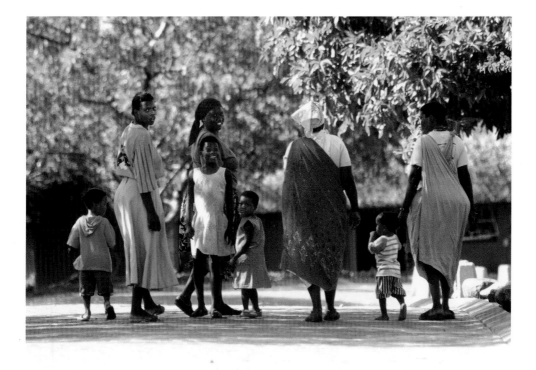

RAINBOW NATION

One of the common misconceptions about South Africa is that it is a nation divided into blacks and whites. Nothing could be further from the truth. The country's first democratic election in 1994 was contested by no less that 19 different parties representing practically every aspect of political, social and religious life. The new Constitution was obliged to give equal status to 11 languages and watching the television channels is an immersion into cross-cultural diversity. These women and children are Shangaan and their vibrant clothes are a fine metaphor for a rainbow nation.

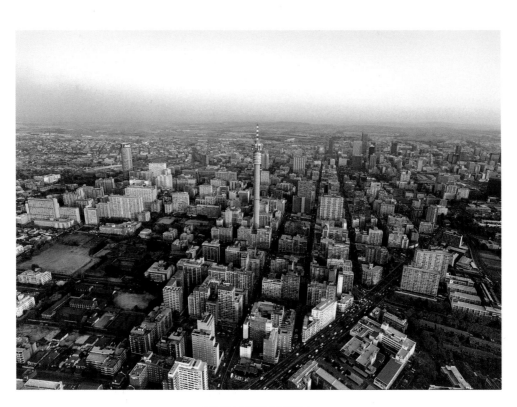

JOHANNESBURG

Some say that the only attraction of Johannesburg is below the ground: in the mines which tunnel into the richest repository of gold in the world. But for those who know its rhythms it's the most exciting city in Africa: intense, vibrant and ever-changing. Gold was discovered there in 1886 and since then the city has never stopped growing. Despite now being buried beneath the buildings, the actual 'ridge of white water' after which the Witwatersrand is named is significant beyond the gold that lies beneath its ancient rocks – it is a watershed. Rain falling to its north drains into the Indian Ocean, while downpours falling south of it drain into the Atlantic.

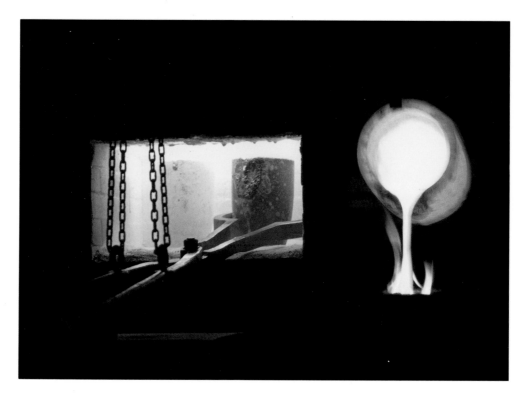

SOUTH AFRICA'S GOLD FIELDS

For thousands of years gold has been the supreme symbol of earthly riches and men have pursued it above all other things. Nowhere has this quest been rewarded in such abundance as in South Africa. About half the gold mined in the world comes from a 500-kilometre arc of mines from Mpumalanga through Gauteng to the Free State. Fifteen years after the discovery of alluvial gold in the eastern Transvaal in 1871, an Australian digger, George Harrison, found gold on the farm Langlaagte, a few kilometres from the future Johannesburg. He staked a 'discoverer's claim' and then, inexplicably, sold his claim for £10. His discovery sparked off a gold rush. The rest, as they say, is history.

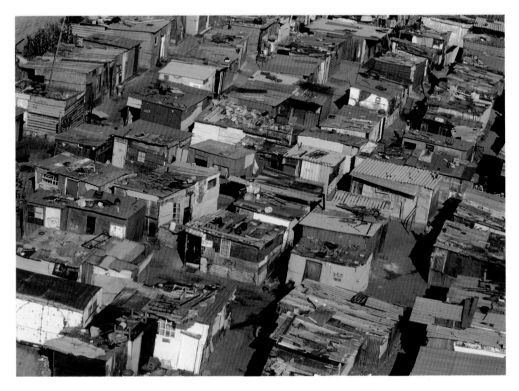

INFORMAL SETTLEMENTS, SOWETO

Poverty in the city appears to be a better option than poverty in the countryside. For this reason, for much of this century, South Africa's urban areas have been a magnet for millions of people wanting a better life. Where housing was not available, they built homes with whatever they could find. In Johannesburg this movement remained fragmented until 1944 when James Mpanza led a mass occupation of open land near Orlando. This started a new social phenomenon in South Africa: squatting. By 1946 the population of his pole-and-hessian settlement was 20,000. The demand for homes continues to outstrip supply, and for many the only viable option is to build their own.

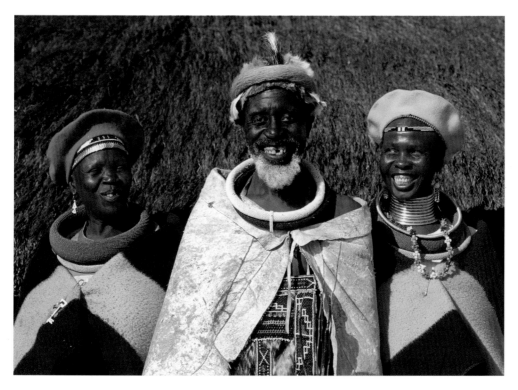

NDEBELE BEADWORK

Above all other things, the Ndebele are masters of colour. But their choice is not merely random: for example, white invokes the tradition of medicine, red the traditions of the Ndau people, and blue the wisdom of kings. These colour codes reach their most sophisticated form in Ndebele beadwork, which is done almost exclusively by women. Through the varieties of beadwork worn, the entire life of the wearer can be traced: from birth through to distinguished matronhood. A distinctive article – almost an Ndebele trade mark – is the *izigolwani*, the handsome beaded rings adorning the neck, arms and legs.

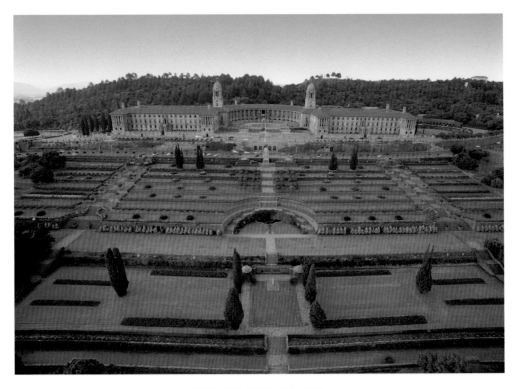

UNION BUILDINGS

The Union Buildings are probably the best-known creation of turn-of-the-century architect Sir Herbert Baker. Built in Renaissance style like an acropolis on Meintjies Kop in Pretoria, they are constructed entirely of local sandstone, an experiment Baker began at the Pretoria Railway Station in 1909. These buildings influenced Baker's later design of the legislative buildings in New Delhi, for which he received a knighthood. The Union Buildings house the administrative headquarters of the South African government and were the scene of President Nelson Mandela's historic inauguration on 10 May 1994.

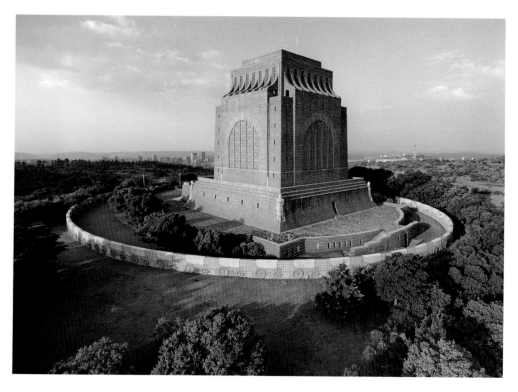

VOORTREKKER MONUMENT

It is difficult to find another event which stirred Afrikaner emotions more between the Anglo-Boer War and the Second World War than the symbolic ox-wagon trek of 1938, planned and organised by the secret *Afrikaner Broederbond* (league of brothers). What began as a fairly inconspicuous attempt to celebrate the centenary of the Great Trek by sending a team of ox wagons from Cape Town to Pretoria, became a rousing national movement. At the final celebrations 200,000 Afrikaners camped for days at Monument Koppie and laid the foundation stone for the Voortrekker Monument. The monument was completed ten years later – the same year in which the Afrikaner Nationalist Party first swept to power.

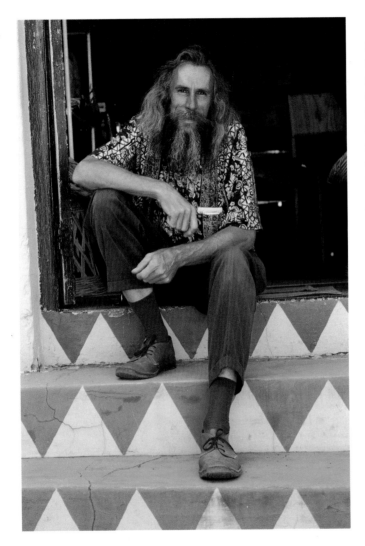

EGBERT VAN BART

Egbert van Bart is one of those unforgettable people who make you imagine a spiritual affinity between hippies and the God-fearing trekkers of the previous century. He's neither, of course – things are sometimes not quite what they first appear to be in the Groot Marico in the North-West – but there's a certain air about him… Egbert owns a curio shop and on occasion works at the Groot Marico Information Centre. He is the local authority on a wide range of topics: he even knows the Latin names of the local fauna and flora. One might call him a student of life.

GROOT MARICO, NORTH-WEST PROVINCE

A glass of mampoer as the sun touches the horizon is a fine thing indeed – if you can handle it. Choosing between local liqueurs or the clear, hellfire brew that bubbles its way through the region's stills, is both a matter of taste and an act of bravery. Oom Schalk Lourens, a fictional character in Herman Charles Bosman's book, *A cask of Jerepigo*, knew what he liked. 'The berries of the karee-boom,' he reflected 'may not make the best mampoer . . . But karee-mampoer is white and soft to look at, and the smoke that comes from it when you pull the cork out of the bottle is pale and rises in slow curves.'

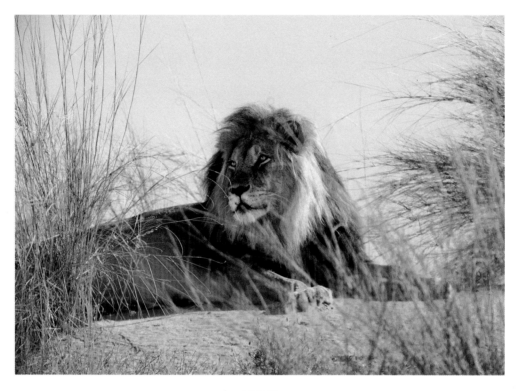

LION

The roar of a lion is one of the most impressive sounds of the wild, striking a note of terror in the hearts of even the most fearless. These tawny cats are the largest African predator and are co-operative hunters, feeding communally on large kills. They can bring down a buffalo four times their weight and have been known to kill bull giraffes weighing over a thousand kilos. Solitary males will rather scavenge a meal than hunt one, and in prides they leave most of the hunting to the females. The large mane of the male lion seemingly assists with obtaining pride dominance and functions to protect the head and neck during fighting.

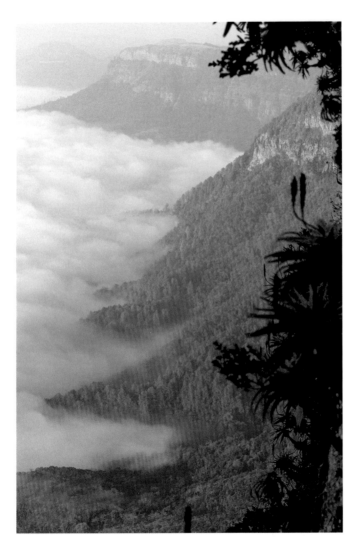

GOD'S WINDOW

In Mpumalanga the seemingly endless plains of the highveld (grasslands) come to an abrupt end in a massive escarpment. Rivers, caught by surprise, plunge over its lip into the steamy valleys and misty forests at its feet. It's an area which has attracted and challenged people for centuries: Pilgrim's Rest recalls a time when gold lured diggers from all over the world; and a statue of Jock of the Bushveld immortalises a famous dog which hunted with its adventurous master in stories by Sir Percy Fitzpatrick. A cleft in the escarpment has been aptly named God's Window.

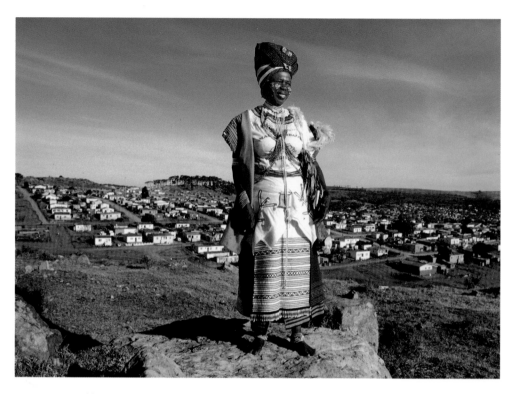

THE SYMBOLISM OF XHOSA TRADITIONAL DRESS

Nowake Jela's clothing is filled with meaning. Her headdress, held together with beaded safety pins, is folded Thembu-style. The act of creating it is known as *ukusentula*. Her long braided skirt, an *umbhaco*, indicates that she is married or marriageable and the number of rows of black braid around the bottom shows her status in her household. She is wearing a beaded collar (*icanci*) and a white beaded neck cascade, similar to an *istokfele*, worn in the last century at stock fairs and swung while dancing. A cotton shawl, called *ibhaye*, is draped over the shoulder. It is also useful for carrying infants on the back.

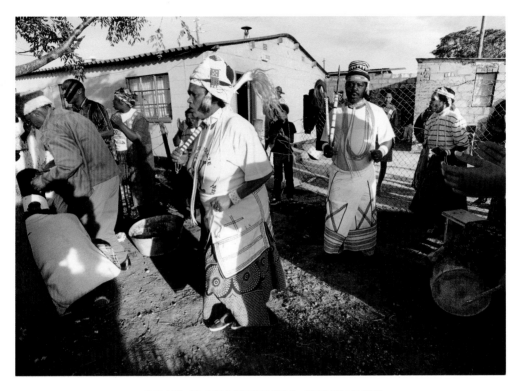

GOAT-SLAUGHTERING CEREMONY

With no warning this *sangoma* in Joza township, Grahamstown, received a spiritual message that an ancestor needed her help. So she called together other healers, and gathered ritual objects and all the appropriate accoutrements and held an ancient sacrificial ceremony. After a ritual of singing and dancing a goat was slaughtered, its blood releasing the pain of the departed spirit. A complex ritual of sacrifices, prayers, songs and dances maintains the link with ancestral spirits. People look to them for protection, and the relationship, either mediated through the *amagqirha* (healers) or part of a family custom, is an important source of wellbeing.

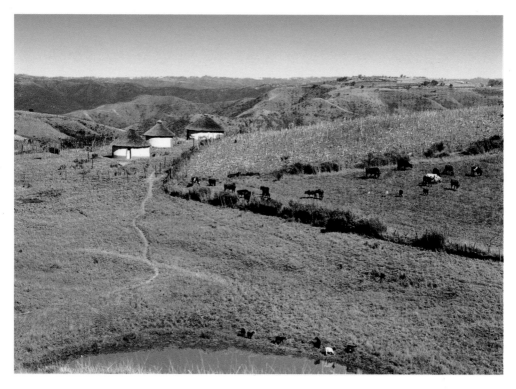

HUTS, WILD COAST

There was a time in the history of the Wild Coast when hippos and crocodiles ruled the rivers, antelope herds covered the hills, elephant gathered in their thousands in the valleys and great predators went unchallenged in the wilderness. Since then, many of these animals have been driven out or killed, but some can still be seen in the unspoiled nature reserves of the Eastern Cape. And even though the wild hunting and grazing grounds have been replaced by fields, kraals, huts and livestock, it is still awe-inspiring country, adorned with rolling grasslands, small swamp forests, steep gorges and a spectacular, evergreen coastline.